HALIFAX

HISTORY TOUR

First published 2010
This edition published 2014

Amberley Publishing
The Hill, Stroud,
Gloucestershire, GL5 4EP
www.amberley-books.com

The right of Stephen Gee to be
identified as the Author of this work
has been asserted in accordance with
the Copyrights, Designs and Patents Act
1988.

ISBN 978 1 4456 4179 9 (print)
ISBN 978 1 4456 4189 8 (ebook)

British Library Cataloguing in
Publication Data.
A catalogue record for this book is
available from the British Library.

Typesetting by Amberley Publishing.
Printed in Great Britain.

INTRODUCTION

It has often been said that Halifax is one of the best preserved Victorian town centres in England. So you would think that any photographic images, with photography only being in its infancy during the Victorian period, would show little change throughout the town – I think not!

One of the other fairly common statements about Halifax is that prior to the Victorian period, the town had many overhanging timbered buildings, if these had also been preserved, the town could have rivalled such places as York and Chester, more famous for their buildings from this earlier era.

Halifax is fortunate that, although extremely rare, photographs exist from the mid-nineteenth century which allows a glimpse into the past, with the overhanging buildings, narrow streets, and cobbled roads. Most of the timbered buildings in the town were demolished in the latter half of the nineteenth century, making way for some of the town's architectural gems such as the Town Hall, designed by Sir Charles Barry and the Halifax Borough Market, designed by Joseph and John Leeming, sons of Alfred Leeming born in Halifax.

These buildings, along with many others, have been preserved and the town rightly deserves praise for the amount of preservation that has taken place, however as you look around the town, many other magnificent buildings have disappeared, making way for more contemporary buildings in the trends of the thirties, forties and sixties, and even now work is ongoing with the next major development of Broad Street and its surrounding area and it is changing once again.

Other buildings have simply been adapted or had their usage altered, sometimes quite dramatically such as the Piece Hall built in 1779, which continues to stand proud as a unique and peerless testimonial to the importance and position Halifax once had in the woollen and cloth trade. The hall was later used as the Wholesale fish, fruit and vegetable market for over 100 years and more latterly the halls 315 rooms have been converted to uses such as an Art Gallery, shops and restaurants; but again schemes are afoot to make even more changes.

Changes though are not just about buildings and their construction but about people, transport and the general way of life. The town once had over thirty cinemas and theatres but not one cinema survives and the Victoria Theatre is the sole surviving purpose-built theatre. However, while plans are being made to incorporate a cinema in the new Broad Street complex, buildings have been adapted such as Hanover Methodist Chapel, now the Playhouse Theatre (opened in 1949), Square Chapel now the Centre for Arts and the Viaduct Theatre at Dean Clough.

Considering the general way of life, gone is the ancient Moot Hall, demolished in 1957, where many criminals were sentenced to have their days cut short by the Halifax Gibbet; for stealing as little as 13½ pence of goods. Down Gaol Lane, the Debtors Prison was

still standing until the early 1970s, although its use as a gaol ended in the mid-1800s. Attached to, and run in conjunction with the gaol, was the Duke of Leeds public house where the prisoners were often found in the tap-room, like the Duke many pubs have closed but others have been opened or simply changed names.

Perhaps one area that has seen more change than any other has been transport. Although the Manchester to Leeds railway line had opened in 1841, Halifax had to wait until 1844 for a branch line to its first railway station at Shaw Syke. The railway system caused many buildings to be demolished; vast viaducts erected and in Halifax necessitated replacement of the North Bridge. Yet, much of the construction has now gone and the proliferation of branch lines to outer districts and other stations in the town is no longer evident.

In 1898, the Halifax tramway system commenced and much traffic was diverted to this new mode of transport. At its peak, in 1929, the tramway system had 106 tram cars on 58 miles of track, yet just over forty years since commencing, the tramway system ceased operation, in 1939. The streets were now filling with motorised vehicles, buses, wagons and the ever increasing use of private cars. It is sometimes hard to remember the many changes, small and large, that have taken place around the town but with the aid of photographic images, covering the last 150 years, these changes become much clearer as we take a tour through the town.

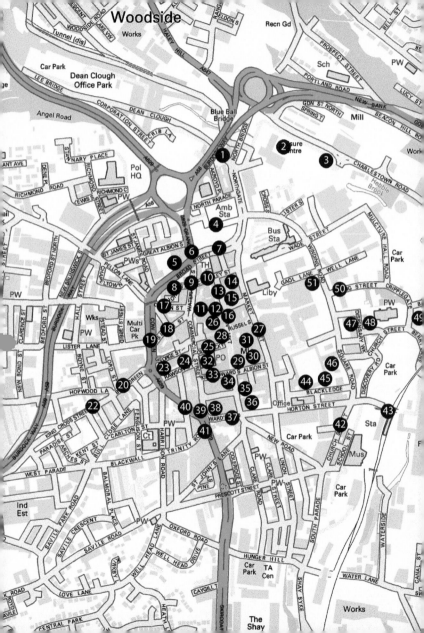

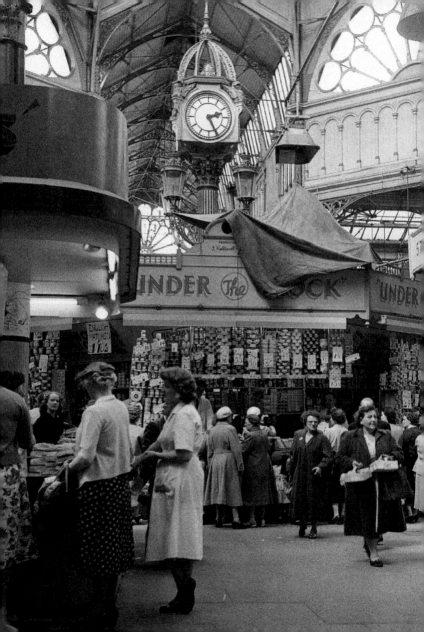

1. CROSS HILLS

Not much has changed here then! In the distance all the mills running up Haley Hill and Range Bank have gone, the chimneys have disappeared and taking their place the Burdock Way Flyover opened in 1973. On the right, all hope of saving the Grand Theatre was dashed when, overnight on 24 May 1956, a ton of ornamental plaster fell from the ceiling into the pit and stalls; the theatre was subsequently demolished in 1957.

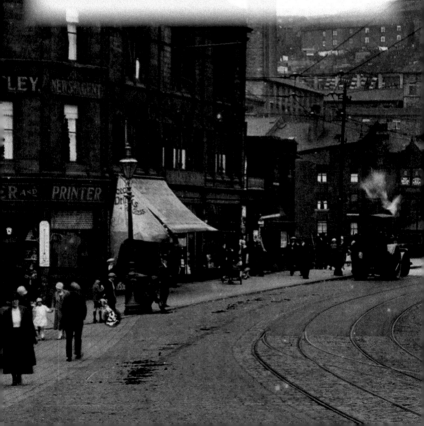

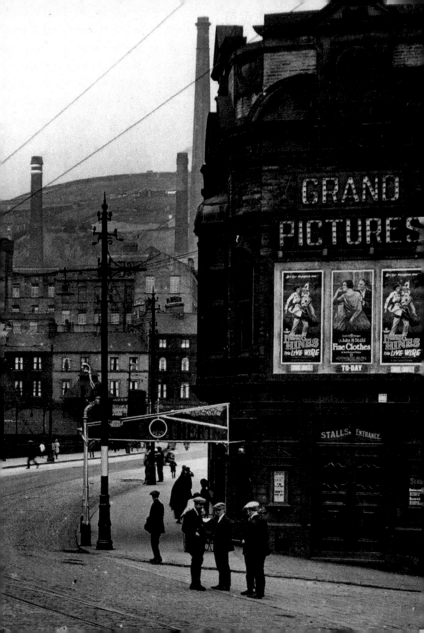

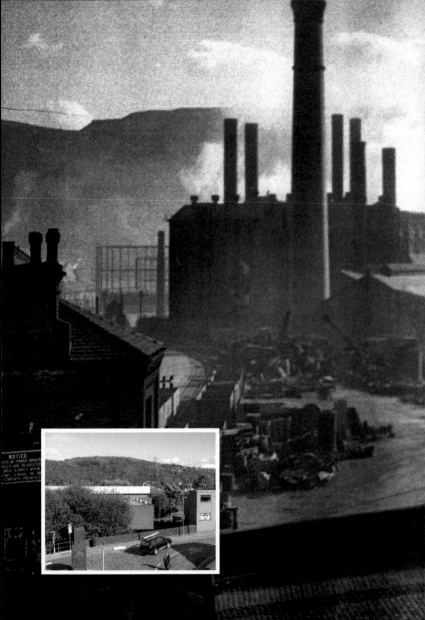

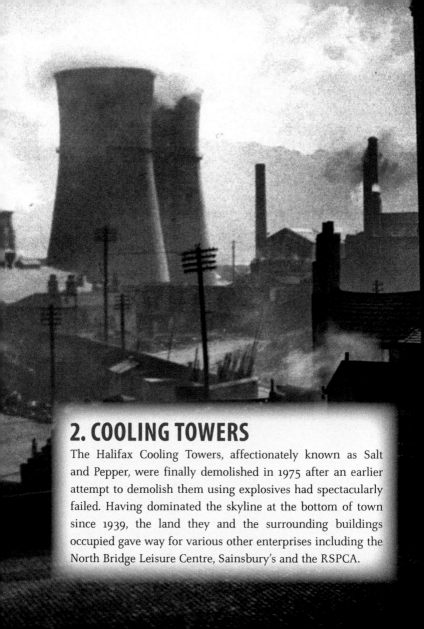

2. COOLING TOWERS

The Halifax Cooling Towers, affectionately known as Salt and Pepper, were finally demolished in 1975 after an earlier attempt to demolish them using explosives had spectacularly failed. Having dominated the skyline at the bottom of town since 1939, the land they and the surrounding buildings occupied gave way for various other enterprises including the North Bridge Leisure Centre, Sainsbury's and the RSPCA.

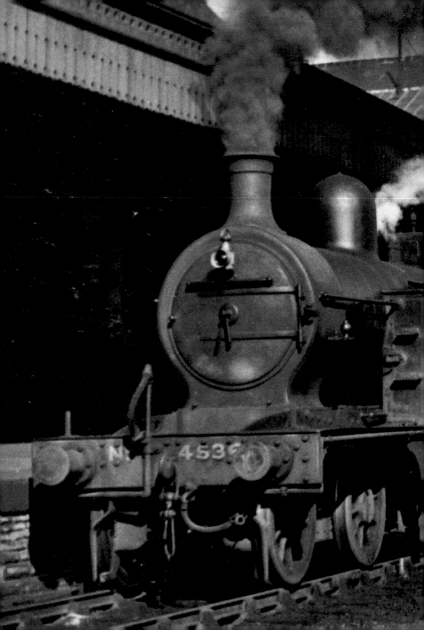

3. NORTH BRIDGE STATION

Looking today, it is hard to believe that the station and goods yard at North Bridge were so important that considerable property along the route had to be demolished, including the North Bridge that had been built of stone in 1774. This was replaced with the current iron bridge, higher and with wider spans to allow rail traffic underneath. The station opened in 1880 and closed to passengers in 1955. Little remains to show the hive of activity, particularly around the large goods yard, most of which is now part of the Calderdale Leisure Centre car park.

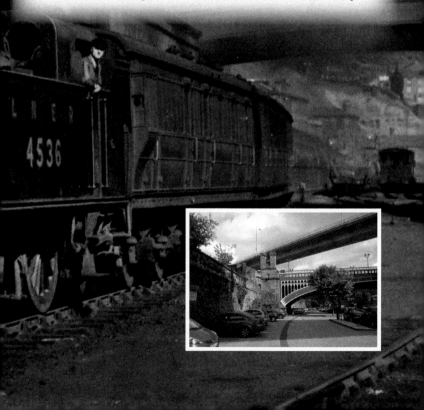

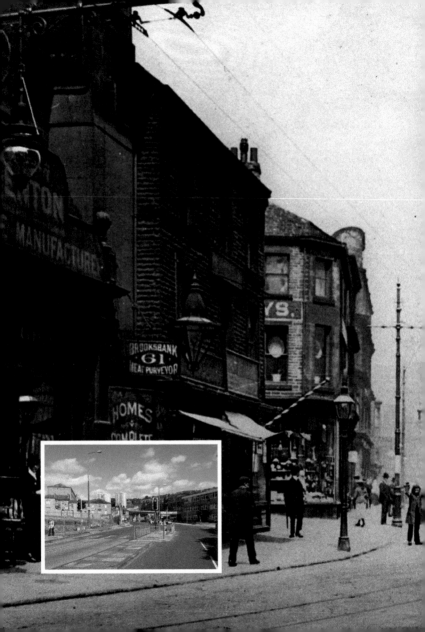

4. NORTHGATE, PORTLAND STREET

Timeform, just past Winding Road, now occupies the site where James Wadsworth once ran his fur store, which he established in 1857. The bottom of Portland Street is on the left. Clearance of the site, which commenced a few years ago, revealed the cellars of the old buildings and, in particular, considerable tile work under what was the Central Stores of the Halifax Industrial Society, just visible, at the bottom of North Parade.

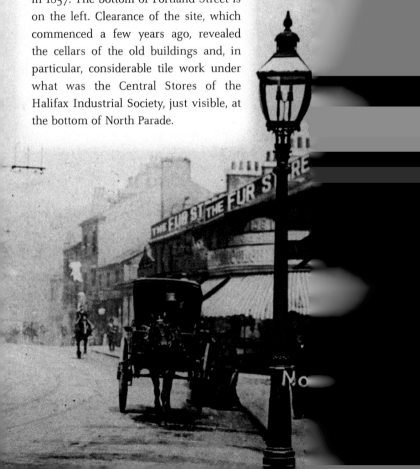

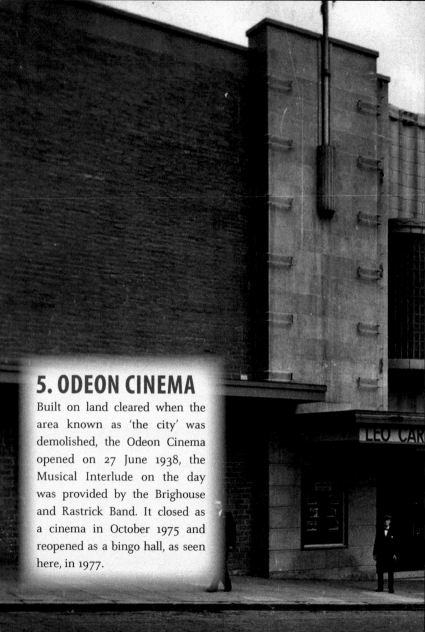

5. ODEON CINEMA

Built on land cleared when the area known as 'the city' was demolished, the Odeon Cinema opened on 27 June 1938, the Musical Interlude on the day was provided by the Brighouse and Rastrick Band. It closed as a cinema in October 1975 and reopened as a bingo hall, as seen here, in 1977.

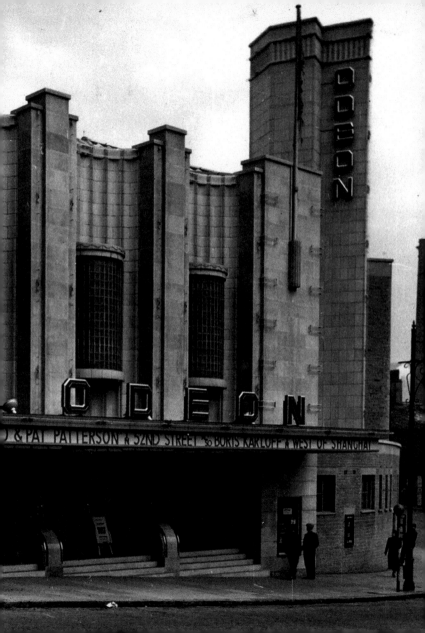

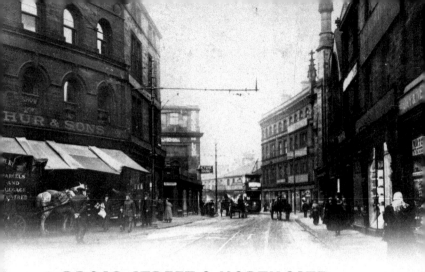

6. BROAD STREET & NORTHGATE

Northgate was once a thriving area of Halifax, with a variety of specialist shops that are now long gone. S. Arthur & Sons, drapers, marked Northgate's junction with Broad Street. Northgate End Unitarian church was demolished in 1982, making way for the new bus station and in the distance the tram is passing where the Timeform premises are now.

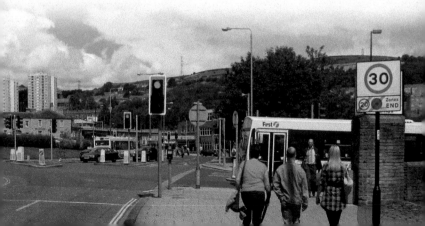

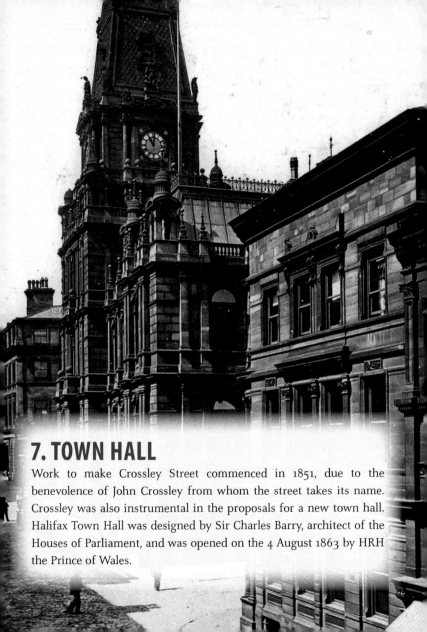

7. TOWN HALL

Work to make Crossley Street commenced in 1851, due to the benevolence of John Crossley from whom the street takes its name. Crossley was also instrumental in the proposals for a new town hall. Halifax Town Hall was designed by Sir Charles Barry, architect of the Houses of Parliament, and was opened on the 4 August 1863 by HRH the Prince of Wales.

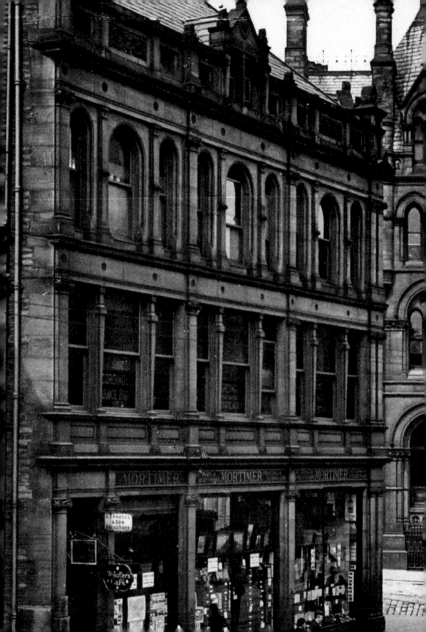

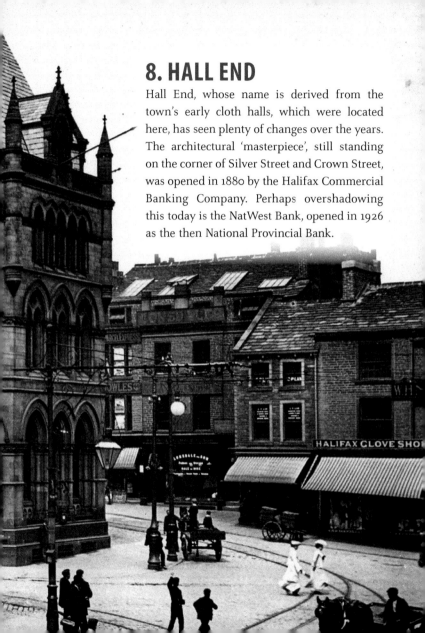

8. HALL END

Hall End, whose name is derived from the town's early cloth halls, which were located here, has seen plenty of changes over the years. The architectural 'masterpiece', still standing on the corner of Silver Street and Crown Street, was opened in 1880 by the Halifax Commercial Banking Company. Perhaps overshadowing this today is the NatWest Bank, opened in 1926 as the then National Provincial Bank.

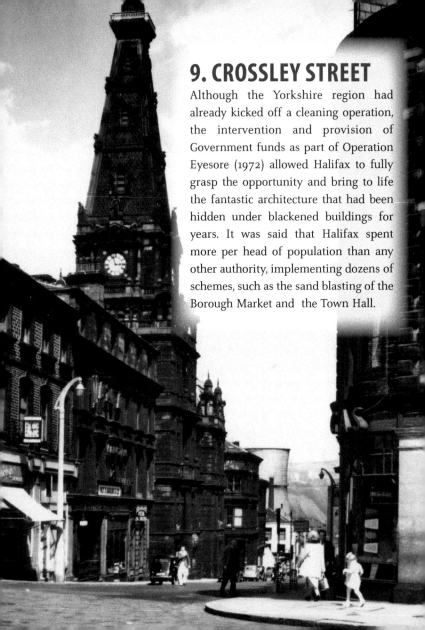

9. CROSSLEY STREET

Although the Yorkshire region had already kicked off a cleaning operation, the intervention and provision of Government funds as part of Operation Eyesore (1972) allowed Halifax to fully grasp the opportunity and bring to life the fantastic architecture that had been hidden under blackened buildings for years. It was said that Halifax spent more per head of population than any other authority, implementing dozens of schemes, such as the sand blasting of the Borough Market and the Town Hall.

10. THE CASTLE

One of the most well-known buildings in Halifax, 'The Castle' was on the site now occupied by TONI&GUY. Whitley & Booth ran their bookshop from the Castle and it was here that the first *Halifax Guardian* was printed in 1832; the editor was George Hogarth, who would later become father-in-law to Charles Dickens when his daughter Catherine married the famous author. The clock in the tower was originally in the Halifax parish church tower. The building was demolished in 1887.

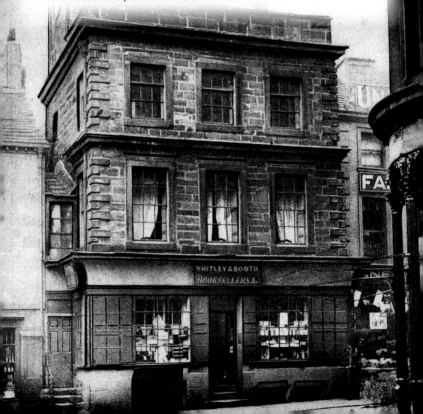

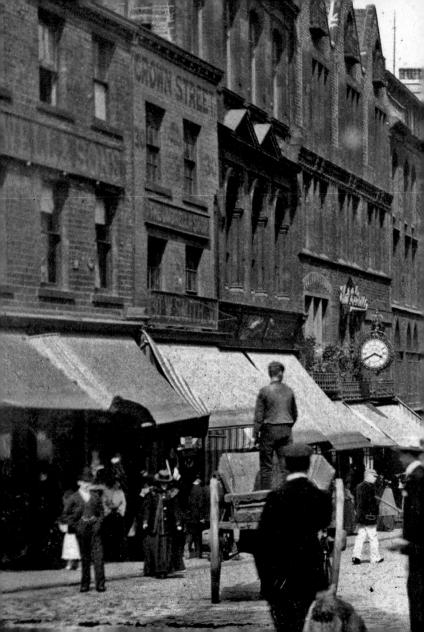

11. SHOE SHOP STREET

Crown Street, known locally as 'shoe shop street', has always been one of Halifax's busier streets, perhaps shown more so in the older view, with horse and carts and various carriages filling the street. Today, vehicles are banned apart from between certain hours. The street lies on the former pack-horse road from Wakefield to Lancashire and was formerly called the High Street.

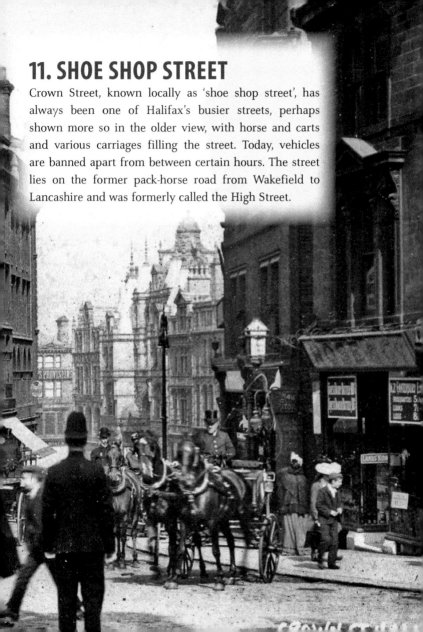

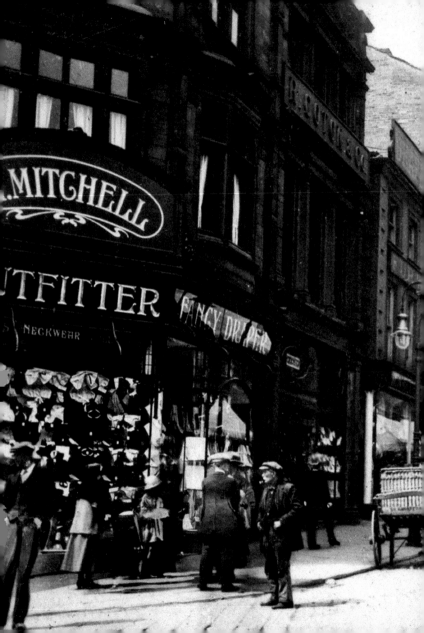

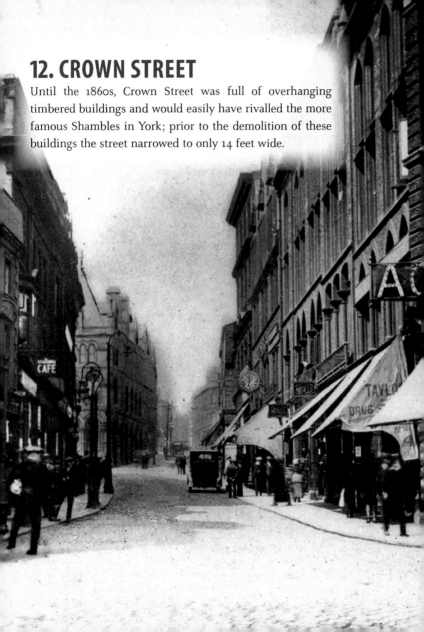

12. CROWN STREET

Until the 1860s, Crown Street was full of overhanging timbered buildings and would easily have rivalled the more famous Shambles in York; prior to the demolition of these buildings the street narrowed to only 14 feet wide.

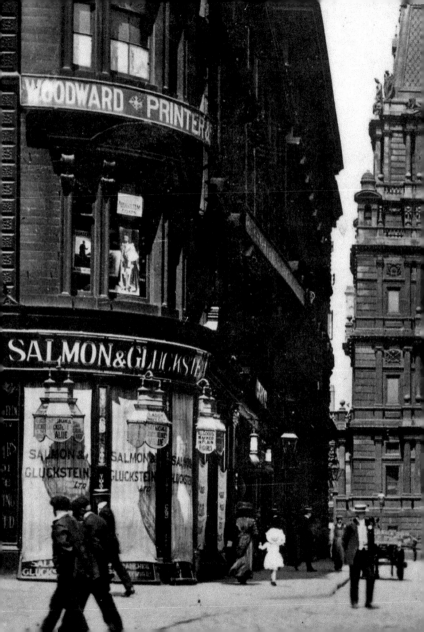

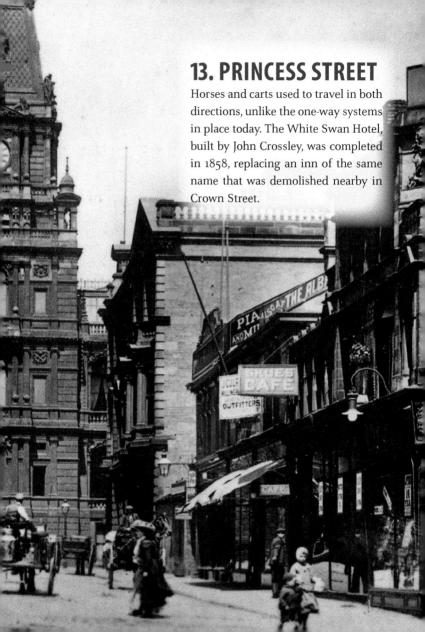

13. PRINCESS STREET

Horses and carts used to travel in both directions, unlike the one-way systems in place today. The White Swan Hotel, built by John Crossley, was completed in 1858, replacing an inn of the same name that was demolished nearby in Crown Street.

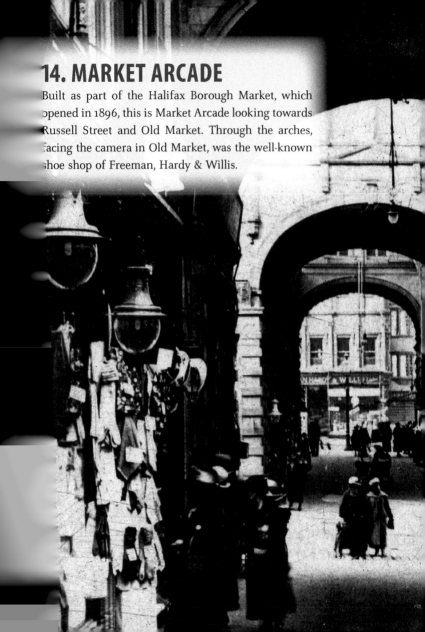

14. MARKET ARCADE

Built as part of the Halifax Borough Market, which opened in 1896, this is Market Arcade looking towards Russell Street and Old Market. Through the arches, facing the camera in Old Market, was the well-known shoe shop of Freeman, Hardy & Willis.

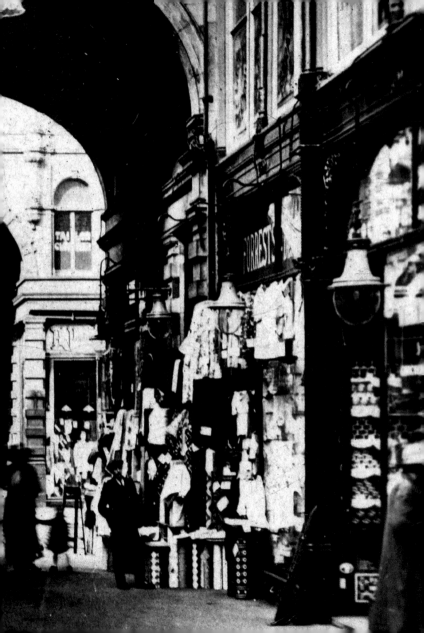

15. OLD MARKET & CORN MARKET

Jessops photography shop now occupies the corner of Old Market and Corn Market, where once Boots the Chemist was located, one of several locations the chemist has occupied in the town. Another store that has moved around the town was Lipton's Grocery Store, seen here on the corner with Princess Street, now occupied by McDonalds.

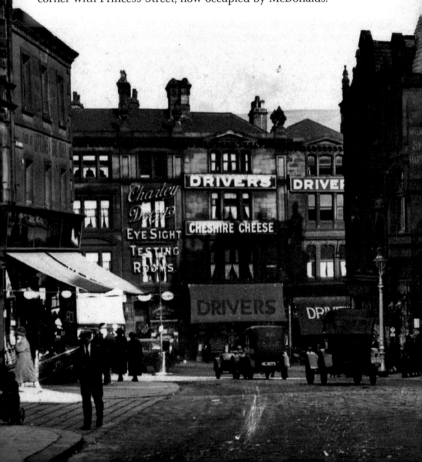

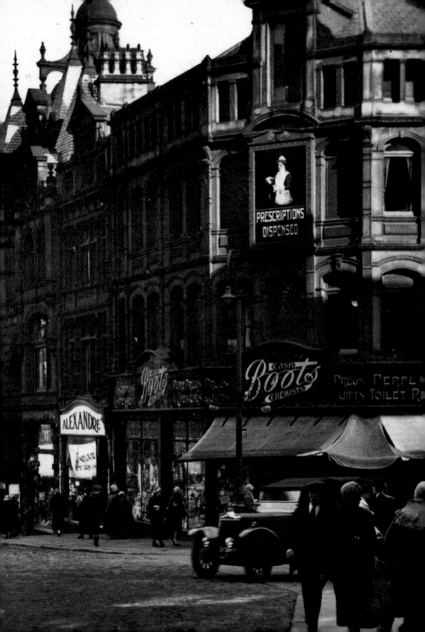

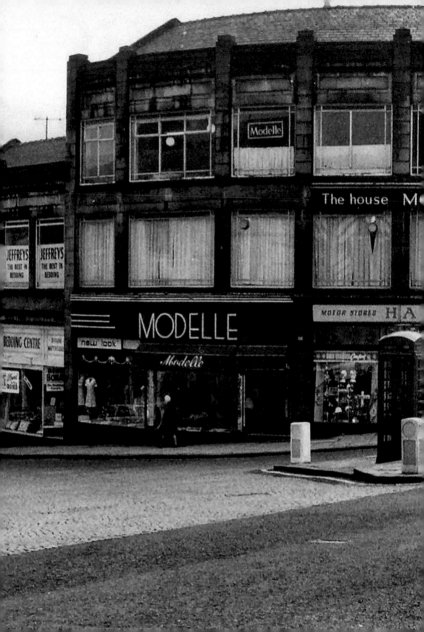

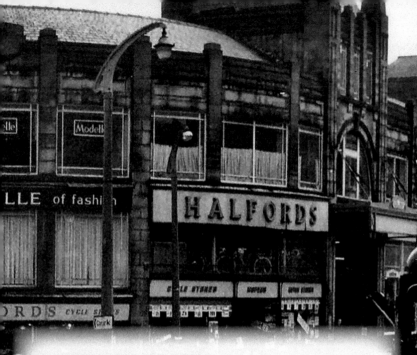

16. PRINCE'S ARCADE

The Prince's Arcade was opened on 2 June 1931 as part of the Woolshops Development, which created twenty-seven shops, fourteen in the actual arcade. The shops included Modelle's, a 'new fashion shop', Walter Rayner's, house furnisher and N. H. Crabtree, 'warm weather wear for modern men'. Later Halfords would take a prominent position where many youngsters bought their first bikes. Down the arcade music could be listened to, before buying, at Rileys music shop and for the philatelist's, Ashton-Jones opened his stamp shop. Ironically, in the 1980s another Woolshops Development came along and most of this property was demolished, the frontage of the arcade was retained and built into the entrance to WHSmith.

17. VICTORY LOUNGE, SILVER STREET

The Victory Lounge was located above Simpson's furniture store on Silver Street, in the building now occupied by Yates Wine Lodge. One of Halifax's many billiard halls was located here and, above the old motor vehicle in the distance in the premises now occupied by Royal Amusements, was another, the Crown Billiard Hall.

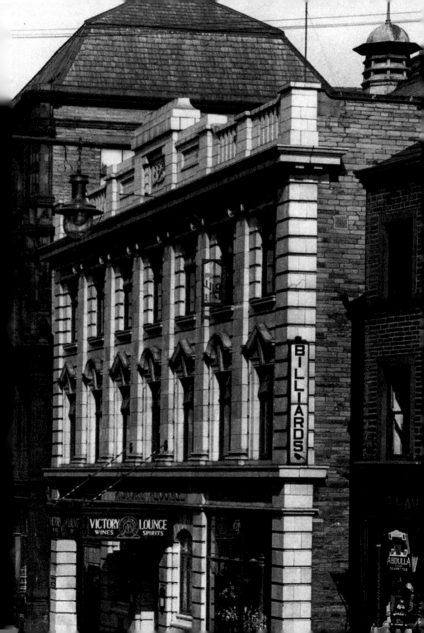

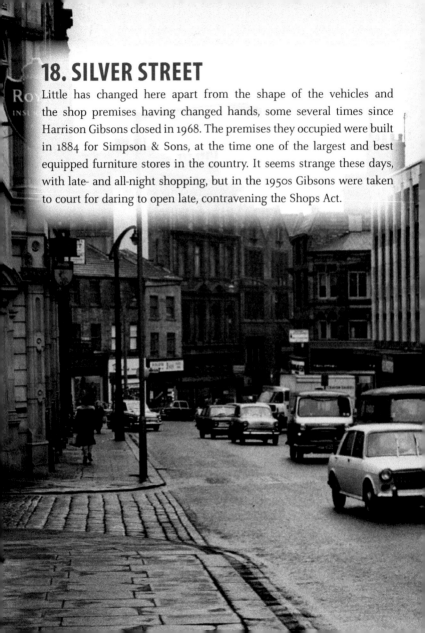

18. SILVER STREET

Little has changed here apart from the shape of the vehicles and the shop premises having changed hands, some several times since Harrison Gibsons closed in 1968. The premises they occupied were built in 1884 for Simpson & Sons, at the time one of the largest and best equipped furniture stores in the country. It seems strange these days, with late- and all-night shopping, but in the 1950s Gibsons were taken to court for daring to open late, contravening the Shops Act.

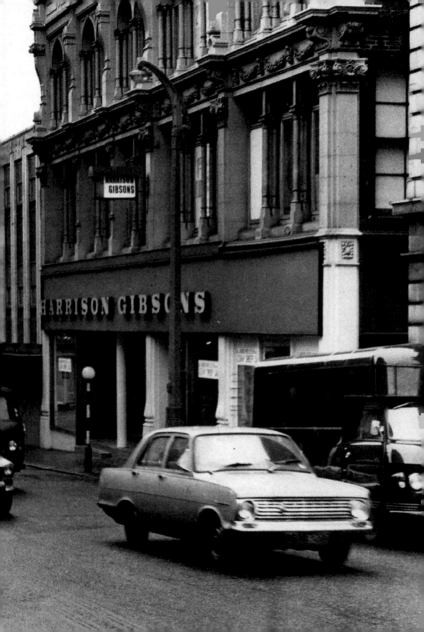

19. COW GREEN

The traffic lights are still here but everything else seems to have changed. At the end of the property, on the left, is the Grand Junction Hotel, formerly the Brown Cow, which closed in 1968 as part of the road widening scheme.

20. BULL GREEN

There have been more schemes to ease traffic in Bull Green, perhaps more than anywhere else in Halifax. Roundabouts have come and gone, relief roads are made but still the traffic comes, at least everything looks to be moving in these pictures looking towards Cow Green. Today, the roads are much wider and the buildings at the bottom of Lister Lane were demolished to make way for the multi-storey car park built in 1971.

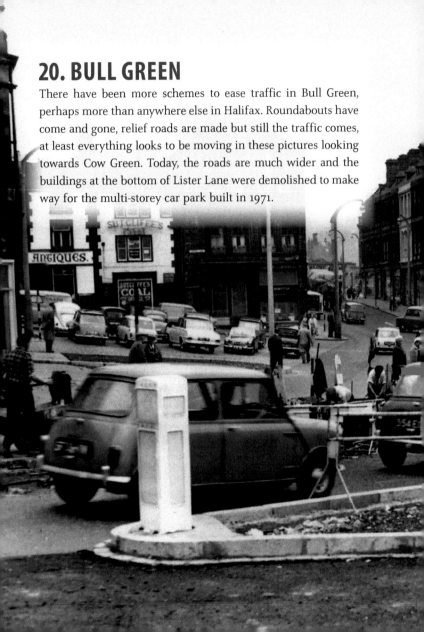

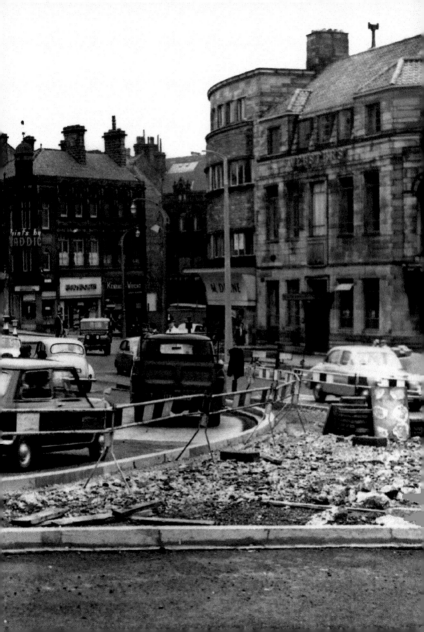

21. LISTER LANE

The premises currently occupied by Walker Singleton help identify these pictures as the bottom of Lister Lane, the same premises being used by J. Sugden, Coal Merchant in the older picture. The properties on the right were demolished in 1968 to allow widening of Cow Green and to make way for the multi-storey car park.

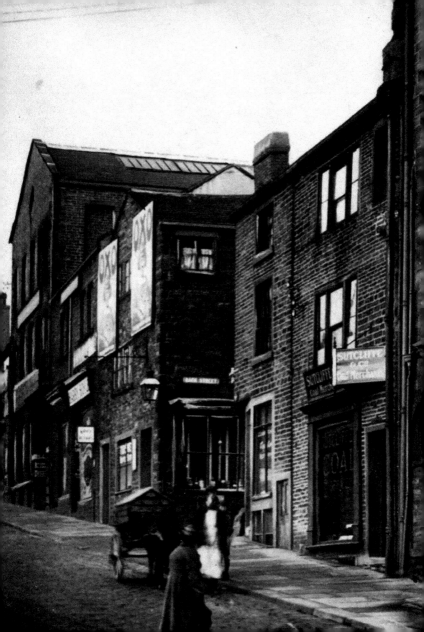

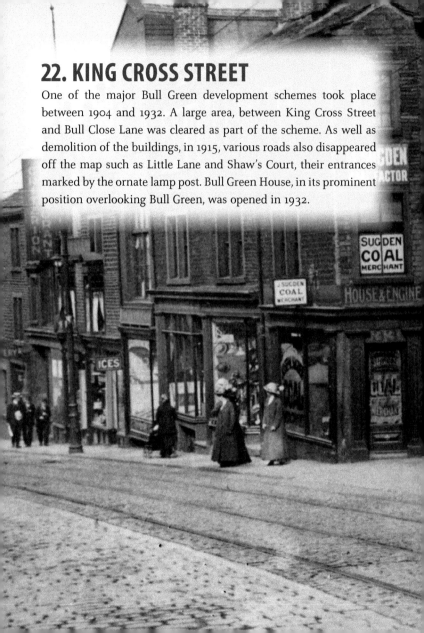

22. KING CROSS STREET

One of the major Bull Green development schemes took place between 1904 and 1932. A large area, between King Cross Street and Bull Close Lane was cleared as part of the scheme. As well as demolition of the buildings, in 1915, various roads also disappeared off the map such as Little Lane and Shaw's Court, their entrances marked by the ornate lamp post. Bull Green House, in its prominent position overlooking Bull Green, was opened in 1932.

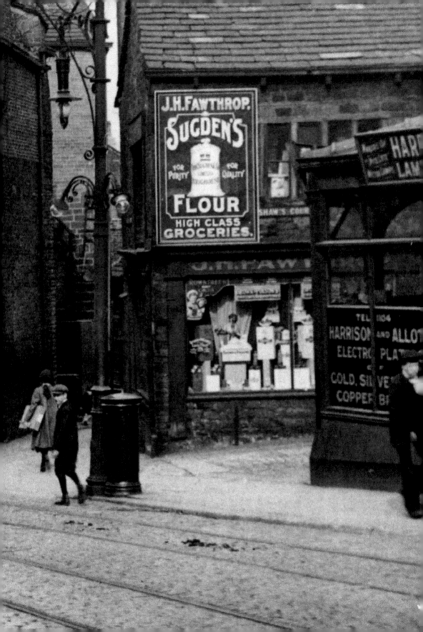

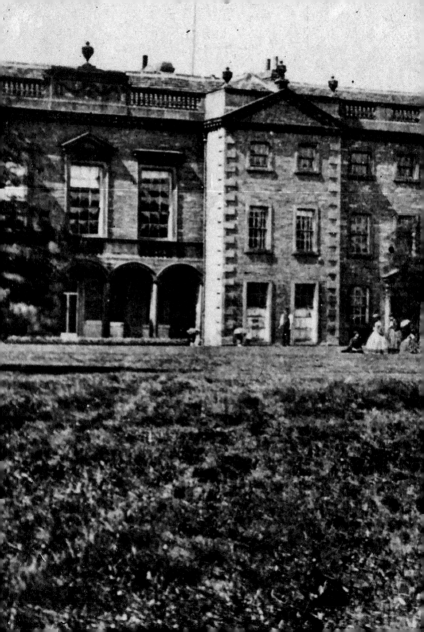

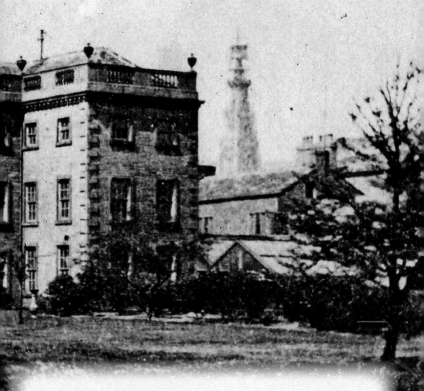

23. SOMERSET HOUSE

Considerable change has taken place around the Somerset House area. The right-hand wing of the house was removed, for the building of what is now Lloyds Bank, in 1898. Fortunately, the rest of the house remains intact and has recently been renovated. To the right of Somerset House, Halifax Town Hall can be seen, apparently nearing completion. Rawson Street runs left to right, while the photograph was taken from Powell Street.

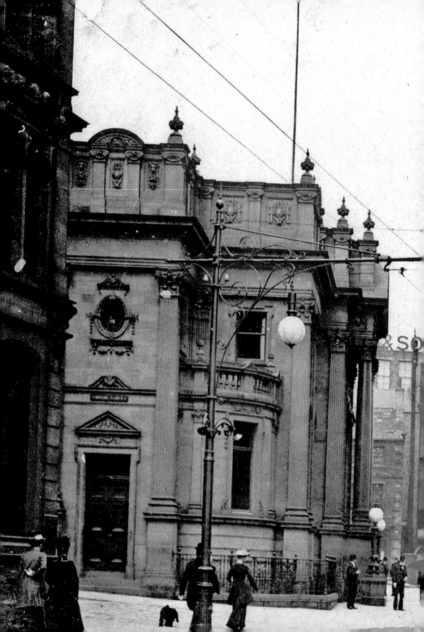

24. LLOYDS BANK

The Lancashire & Yorkshire Bank Chambers, built in 1892, are now part of Harveys Department Store at the bottom of Rawson Street and opposite the imposing Lloyds Bank Building. The bank premises were purpose built for the Halifax and Huddersfield Union Banking Company and opened in May 1898. The bank's customers must have been used to being served in grandeur as prior to this building the Banking Hall was in the 'Grand Salon' of Somerset House.

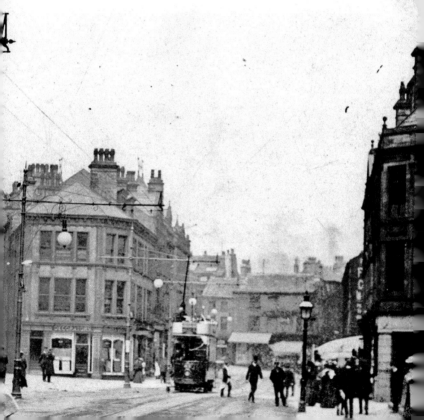

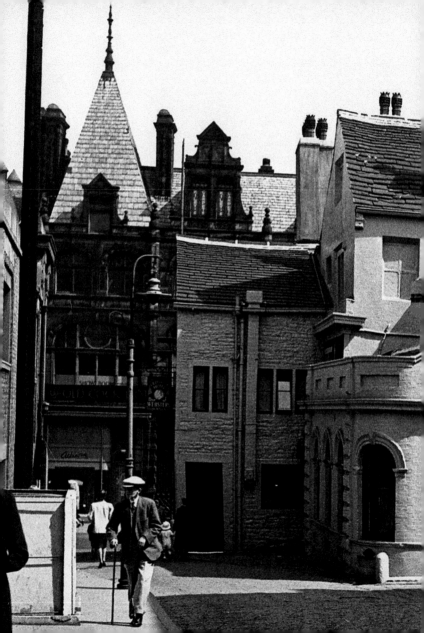

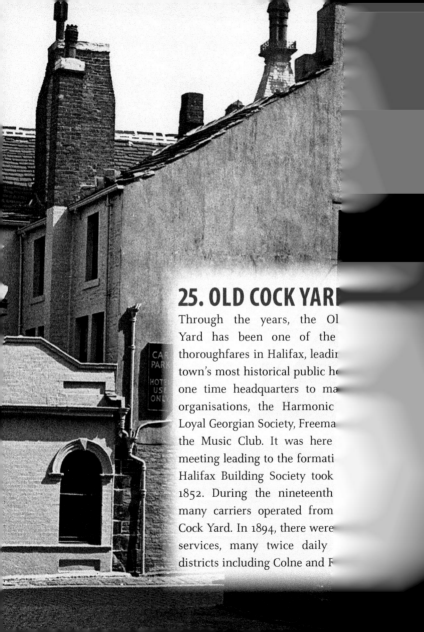

25. OLD COCK YARD

Through the years, the Old Yard has been one of the thoroughfares in Halifax, leading town's most historical public h one time headquarters to ma organisations, the Harmonic Loyal Georgian Society, Freema the Music Club. It was here meeting leading to the formati Halifax Building Society took 1852. During the nineteenth many carriers operated from Cock Yard. In 1894, there were services, many twice daily districts including Colne and F

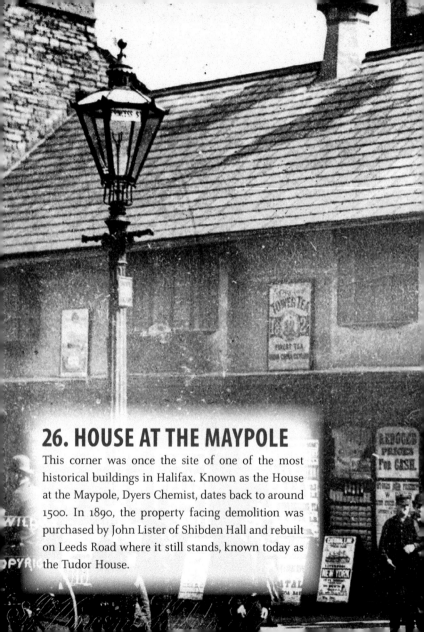

26. HOUSE AT THE MAYPOLE

This corner was once the site of one of the most historical buildings in Halifax. Known as the House at the Maypole, Dyers Chemist, dates back to around 1500. In 1890, the property facing demolition was purchased by John Lister of Shibden Hall and rebuilt on Leeds Road where it still stands, known today as the Tudor House.

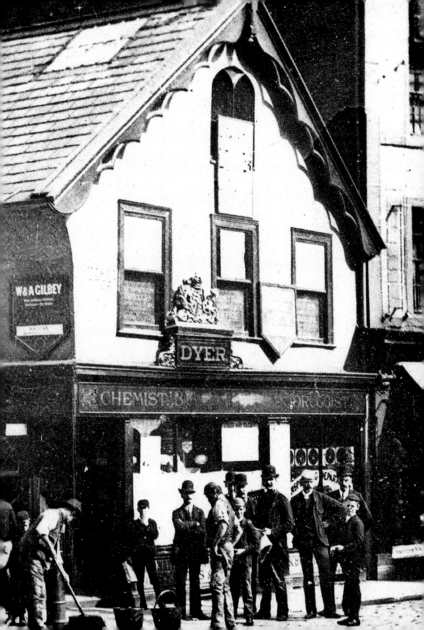

27. MARKET STREET & RUSSELL STREET

The corner of Market Street and Russell Street, showing very distinct architectural styles. The old picture shows the Saddle Pub, rebuilt in the 1890s in a style that blended well with the then new Borough Market. Unfortunately, when the pub closed in 1966, the building was demolished and a contemporary 1960s style building was erected. The premises have since been used by Lipton's, the Electricity Showroom and JJB Sports.

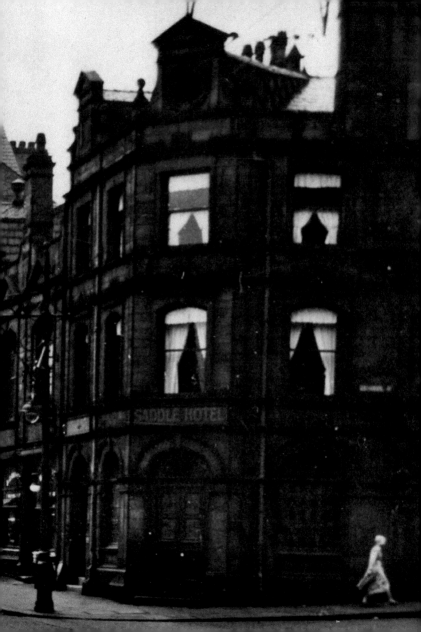

28. ARCADE ROYALE

Joining Southgate to Commercial Street, the Arcade Royale was opened on the 5 October 1912. Designed by Clement Williams & Sons, the frontages on King Edward Street and Southgate were made of White Marmo. Apart from shops, provision was also made for a sixteen-table luxurious Billiard Hall with large pictures of Venice worked into the walls. Unfortunately, the arcade was lost in the late 1960s, when the Co-operative Society, who had bought the arcade in 1949, converted it into one large store. The buildings now comprise of a number of flats, smaller retail units and The Goose public house.

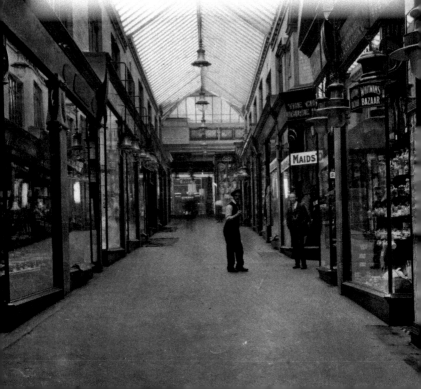

29. 'OLD MARKS & SPENCER'

The sign of the Old Cock Hotel on Southgate gives this location away with all the other buildings long gone. The Cash Store in the 1880s photograph was demolished in the 1930s, when Marks & Spencer opened their new store at the location, on 3 February 1933. Marks & Spencer later moved to their existing Woolshops premises and Wilkinson's now occupy this site.

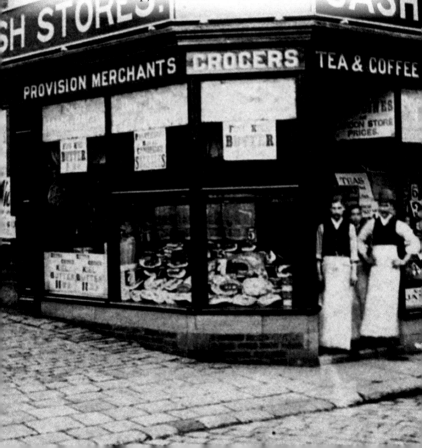

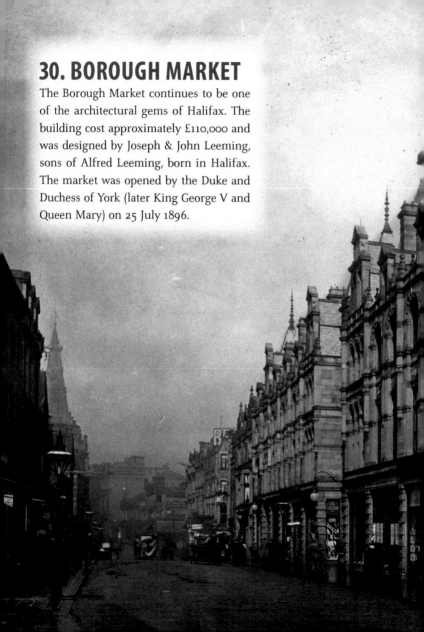

30. BOROUGH MARKET

The Borough Market continues to be one of the architectural gems of Halifax. The building cost approximately £110,000 and was designed by Joseph & John Leeming, sons of Alfred Leeming, born in Halifax. The market was opened by the Duke and Duchess of York (later King George V and Queen Mary) on 25 July 1896.

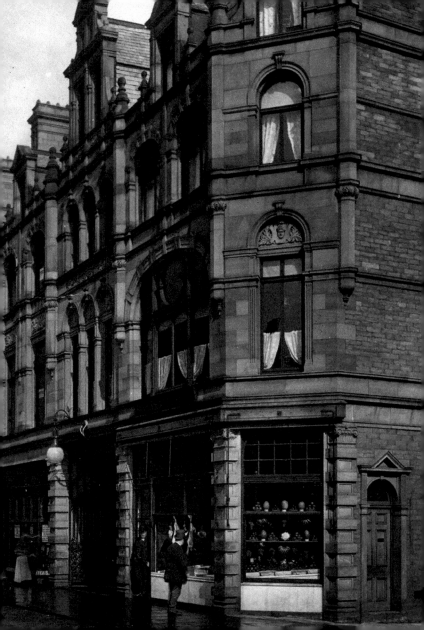

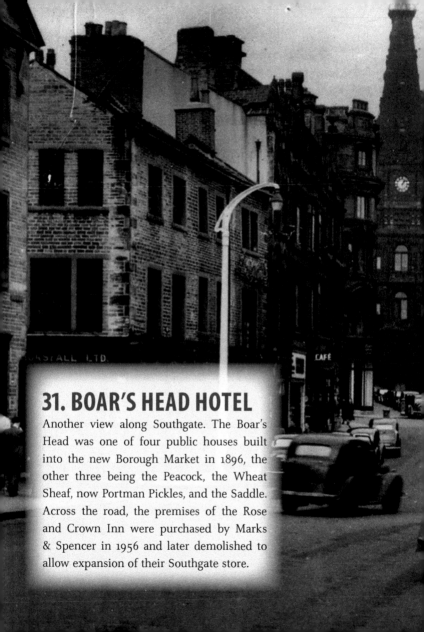

31. BOAR'S HEAD HOTEL

Another view along Southgate. The Boar's Head was one of four public houses built into the new Borough Market in 1896, the other three being the Peacock, the Wheat Sheaf, now Portman Pickles, and the Saddle. Across the road, the premises of the Rose and Crown Inn were purchased by Marks & Spencer in 1956 and later demolished to allow expansion of their Southgate store.

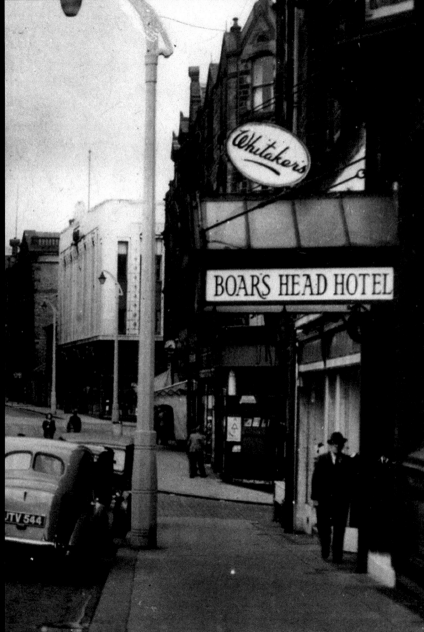

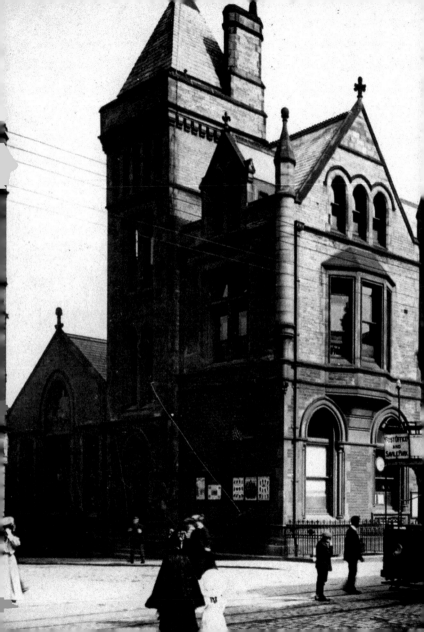

32. POST OFFICE

The main part of the Halifax General Post Office, designed by Henry Tanner, architect to the district's Board of Works, remains very much as when it opened on 23 June, 1887. Extensions to the rear, into the Old Cock Yard, were made in 1926/27, when an automated telephone exchange was added. Further extensions were made in 1957, providing additional space for the sorting office and telephone exchange.

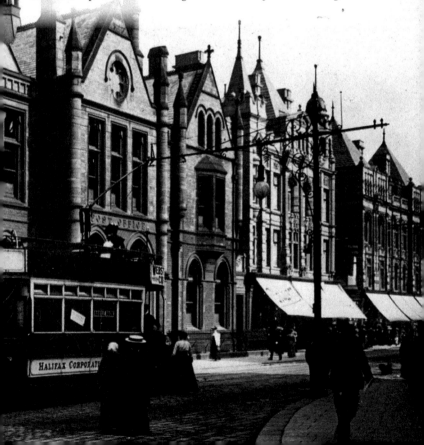

33. KING EDWARD STREET

While the impressive architecture of the Arcade Royale has been preserved on the left of King Edward Street, the Café Royal on the right was incorporated into the Alexandra Hall, which opened in 1931 and was built for the continued expansion of the Halifax Building Society. As part of the scheme the café was renamed to the Alexandra Café but would later totally disappear as the Halifax further extended their office space. In the distance, properties on Thomas Street face the photographer as Albion Street extended over Market Street, until Westgate House was built, opening in 1971.

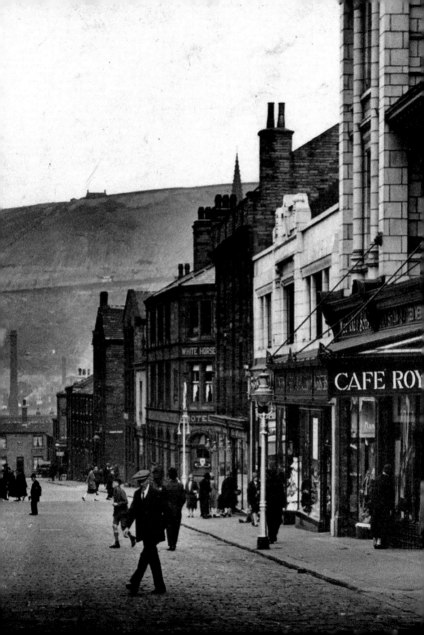

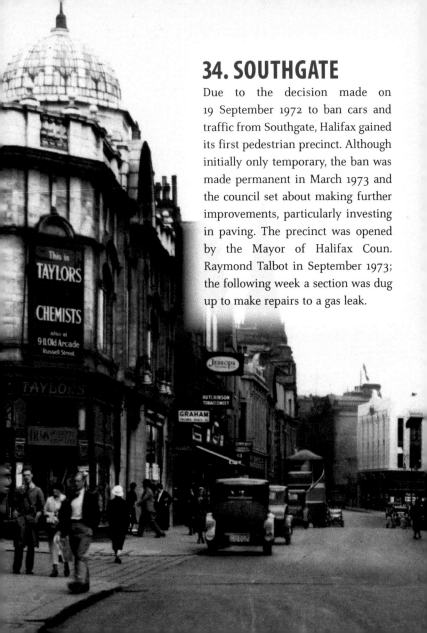

34. SOUTHGATE

Due to the decision made on 19 September 1972 to ban cars and traffic from Southgate, Halifax gained its first pedestrian precinct. Although initially only temporary, the ban was made permanent in March 1973 and the council set about making further improvements, particularly investing in paving. The precinct was opened by the Mayor of Halifax Coun. Raymond Talbot in September 1973; the following week a section was dug up to make repairs to a gas leak.

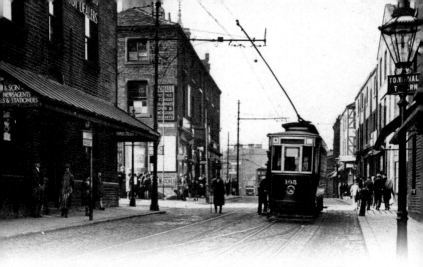

35. OLD TOWN HALL, UNION STREET

The Halifax tramway system is long gone, and cars now use the parking bays near the Westgate, Opposite the Westgate, WHSmith & Son were in the building now occupied by John & Randolph Bottomley. the building was used as the town hall prior to 1863. Next to the 'Old Town Hall' is the award-winning Westgate Arcade; built in 2006 and awarded a Halifax Civic Trust Award in 2007.

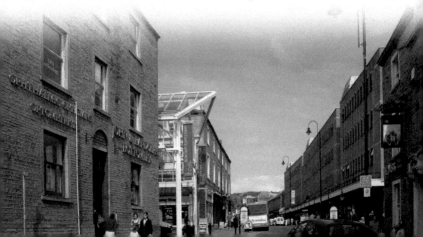

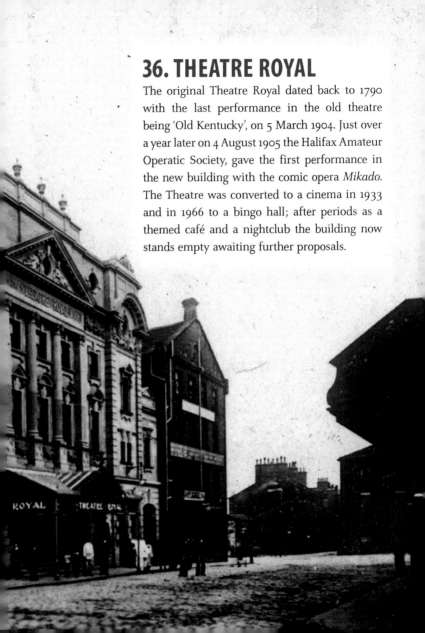

36. THEATRE ROYAL

The original Theatre Royal dated back to 1790 with the last performance in the old theatre being 'Old Kentucky', on 5 March 1904. Just over a year later on 4 August 1905 the Halifax Amateur Operatic Society, gave the first performance in the new building with the comic opera *Mikado*. The Theatre was converted to a cinema in 1933 and in 1966 to a bingo hall; after periods as a themed café and a nightclub the building now stands empty awaiting further proposals.

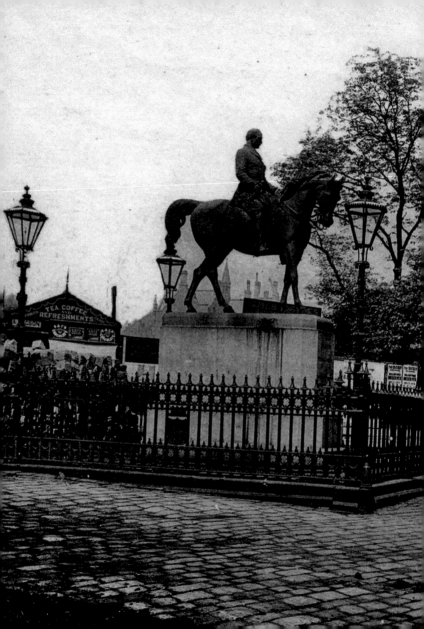

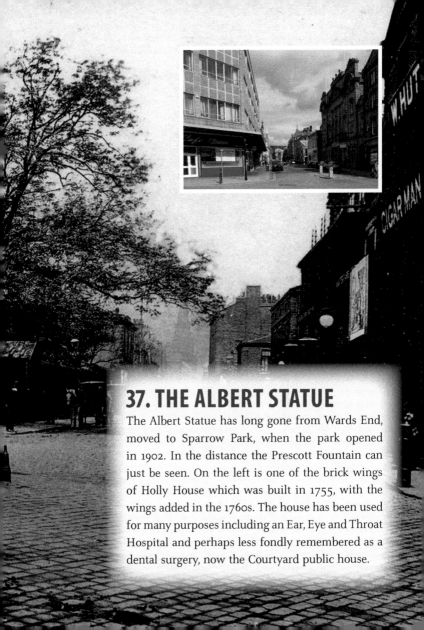

37. THE ALBERT STATUE

The Albert Statue has long gone from Wards End, moved to Sparrow Park, when the park opened in 1902. In the distance the Prescott Fountain can just be seen. On the left is one of the brick wings of Holly House which was built in 1755, with the wings added in the 1760s. The house has been used for many purposes including an Ear, Eye and Throat Hospital and perhaps less fondly remembered as a dental surgery, now the Courtyard public house.

38. PALACE THEATRE

The Palace Theatre opened in 1903 and was to attract stars such as Charlie Chaplin, Sir Harry Lauder and George Formby before a decision to close the theatre was made in 1959, due to dwindling audiences. Following demolition the same year, work quickly commenced on erecting the four-storey office block, Southgate House, with its best-known tenant the Inland Revenue.

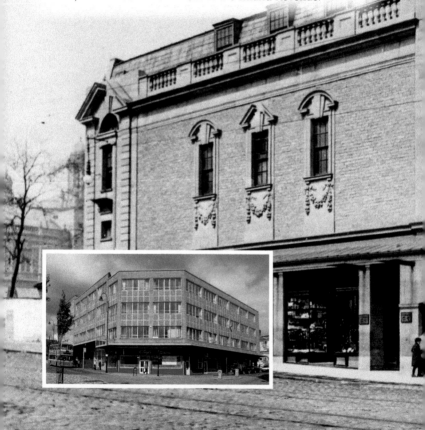

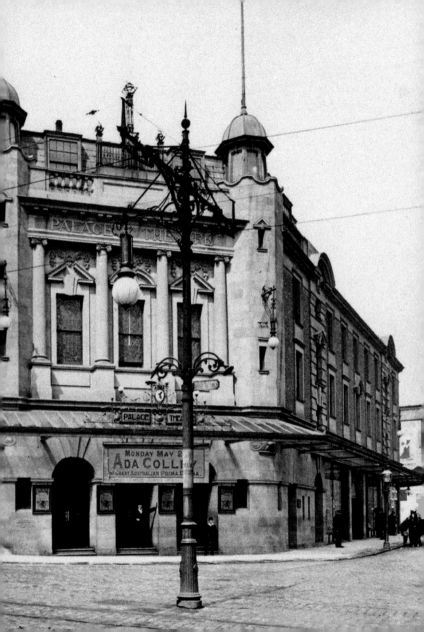

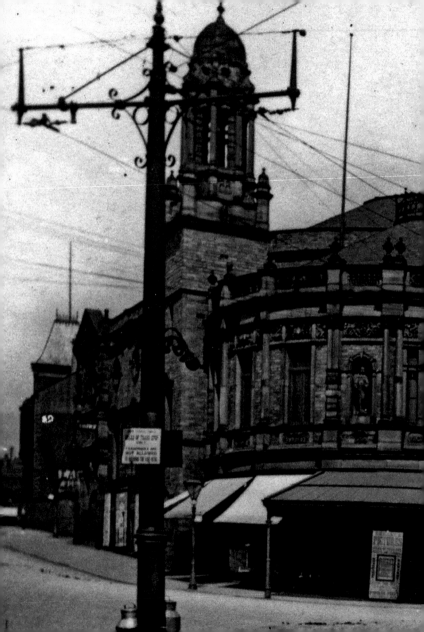

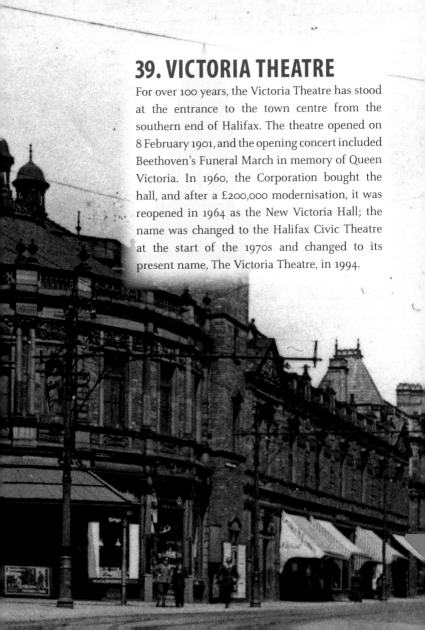

39. VICTORIA THEATRE

For over 100 years, the Victoria Theatre has stood at the entrance to the town centre from the southern end of Halifax. The theatre opened on 8 February 1901, and the opening concert included Beethoven's Funeral March in memory of Queen Victoria. In 1960, the Corporation bought the hall, and after a £200,000 modernisation, it was reopened in 1964 as the New Victoria Hall; the name was changed to the Halifax Civic Theatre at the start of the 1970s and changed to its present name, The Victoria Theatre, in 1994.

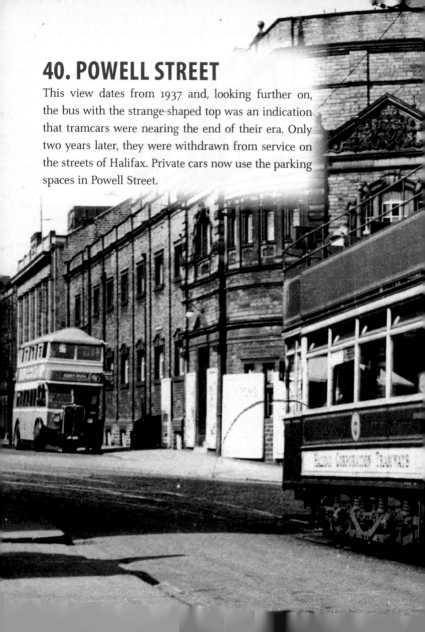

40. POWELL STREET

This view dates from 1937 and, looking further on, the bus with the strange-shaped top was an indication that tramcars were nearing the end of their era. Only two years later, they were withdrawn from service on the streets of Halifax. Private cars now use the parking spaces in Powell Street.

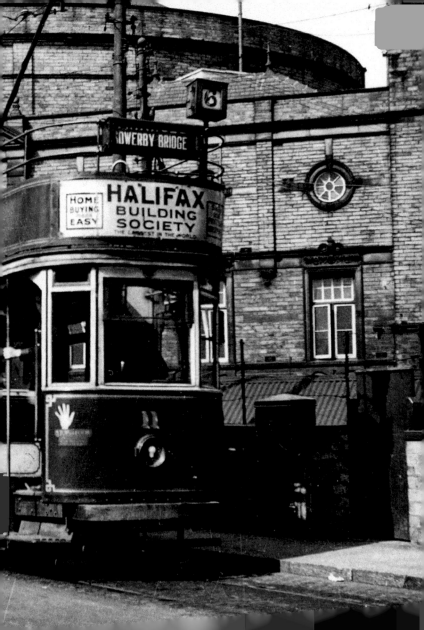

41. PICTURE HOUSE

The Picture House, opened on 20 October 1913, was one of the first purpose-built cinemas in Halifax. It was also the first to show talkies in the town, with Al Jolson in *The Singing Fool* in 1929. In 1948, its name was changed to the Gaumont. Having spent ten years as a bingo hall, it was reopened in 1973 as the Astra cinema. It closed in 1982, reopening in 1987 as the Coliseum nightclub (now Liquid).

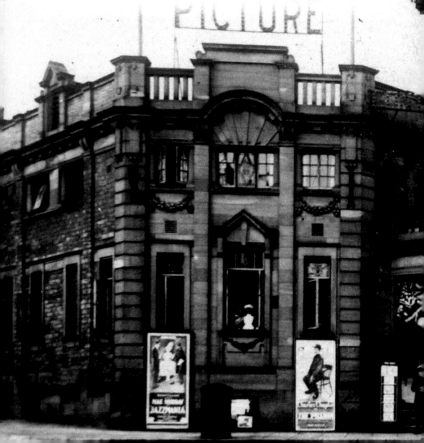

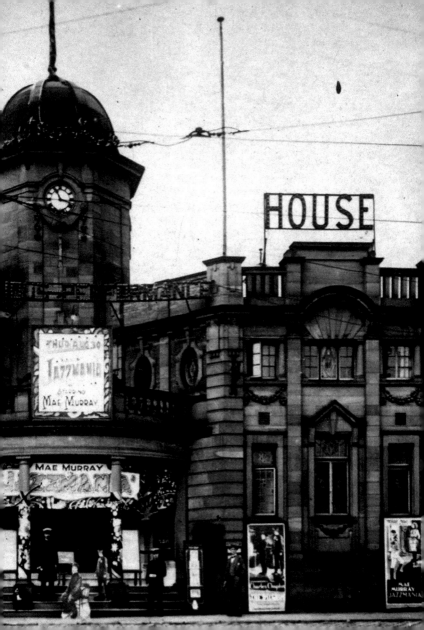

42. CHURCH STREET

Having become structurally unsafe, the two seventeenth-century houses in Church Street were demolished in 1949, opening up the view of the Ring O' Bells and the Halifax parish church. The church, dedicated to St John the Baptist, was granted Minster status on 23 November 2009.

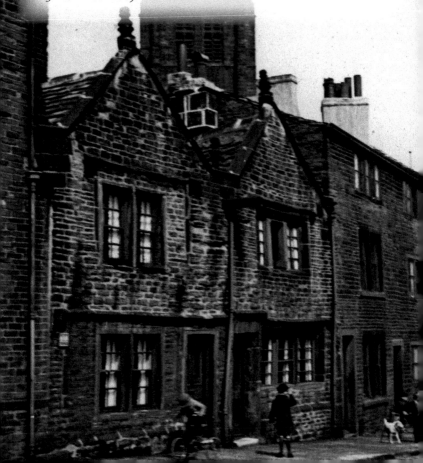

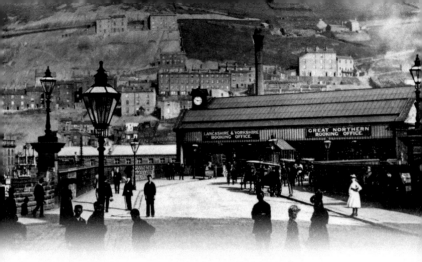

43. HALIFAX RAILWAY STATION

There was a time when people did not rely on private transport as much as they do now, as clearly shown in these pictures of the Halifax railway station. The railway system was more widely used and Halifax had an abundance of stations in the outer districts as well as in the town. The first Halifax station opened at Shaw Syke in 1844, followed in 1855 by the first station on the present site.

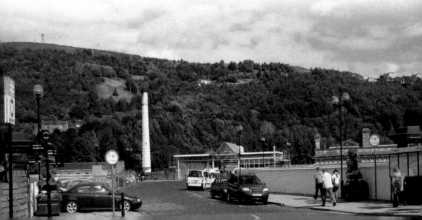

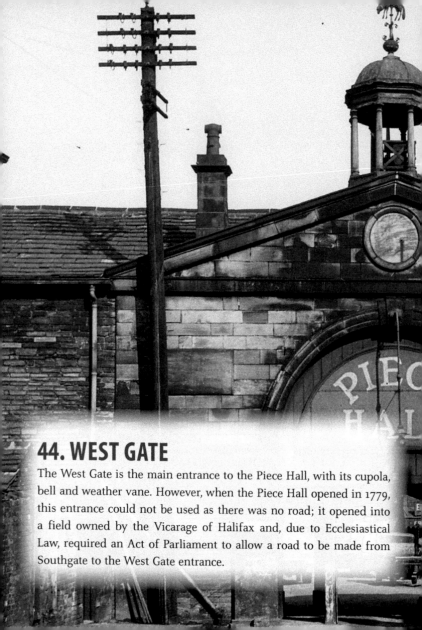

44. WEST GATE

The West Gate is the main entrance to the Piece Hall, with its cupola, bell and weather vane. However, when the Piece Hall opened in 1779, this entrance could not be used as there was no road; it opened into a field owned by the Vicarage of Halifax and, due to Ecclesiastical Law, required an Act of Parliament to allow a road to be made from Southgate to the West Gate entrance.

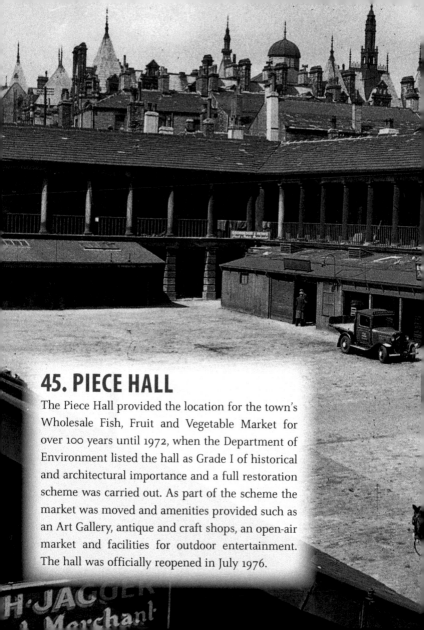

45. PIECE HALL

The Piece Hall provided the location for the town's Wholesale Fish, Fruit and Vegetable Market for over 100 years until 1972, when the Department of Environment listed the hall as Grade I of historical and architectural importance and a full restoration scheme was carried out. As part of the scheme the market was moved and amenities provided such as an Art Gallery, antique and craft shops, an open-air market and facilities for outdoor entertainment. The hall was officially reopened in July 1976.

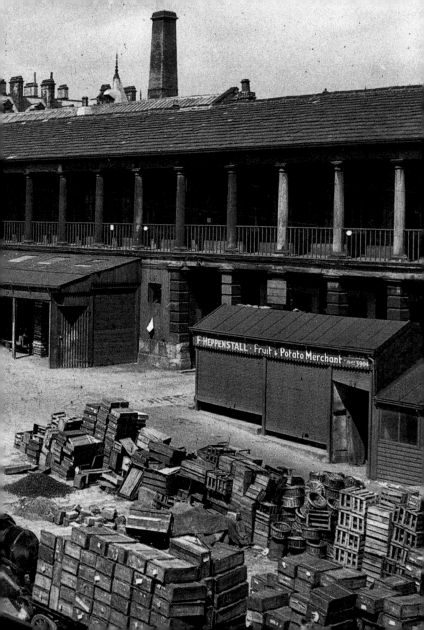

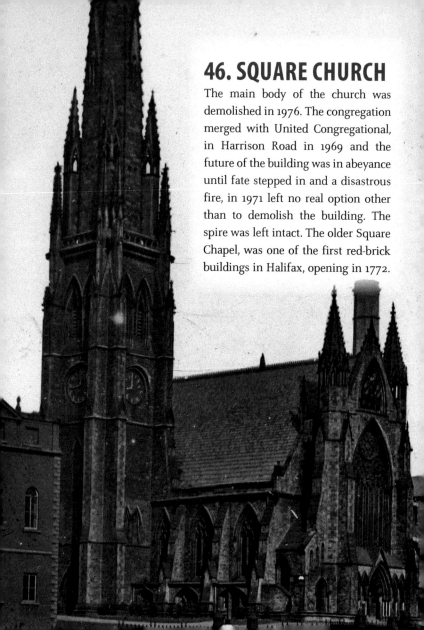

46. SQUARE CHURCH

The main body of the church was demolished in 1976. The congregation merged with United Congregational, in Harrison Road in 1969 and the future of the building was in abeyance until fate stepped in and a disastrous fire, in 1971 left no real option other than to demolish the building. The spire was left intact. The older Square Chapel, was one of the first red-brick buildings in Halifax, opening in 1772.

47. CAUSEWAY

The West Gate to the Halifax Minster is no longer on Upper Kirkgate but it has moved forward and is adjacent to the Church School, now the Church Hall. The old stocks, which were at the left-hand side of the gate, are now to the right. The changes took place as part of the 'improved precinct' scheme around, the then Halifax parish church, carried out in the mid-1960s.

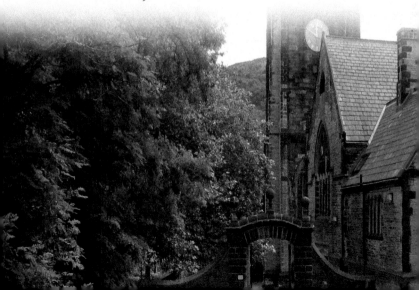

48. HALIFAX PARISH CHURCH SCHOOL

Making a slight departure from other pictures in this book, here we see the main building looking cleaner in the older picture. This is because the photograph was taken shortly after the new Halifax Parish Church School had just been built; the school opened on 10 June 1867.

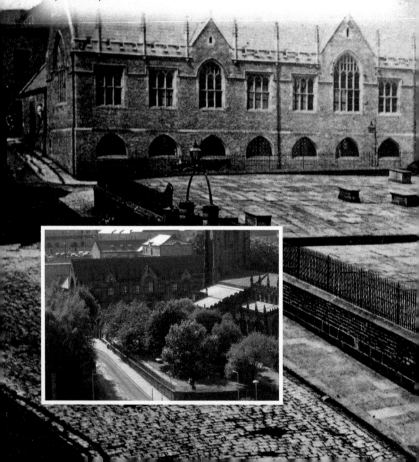

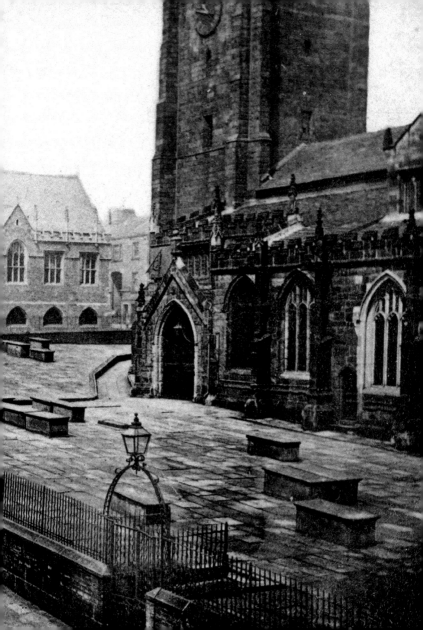

49. CLARK BRIDGE

The demolition of the railway viaduct in 1981 opened up the view that can now be seen of the Halifax Minster, Square Church Spire and various other buildings nearer the town centre. The 480-yard viaduct opened in 1874 and was a major architectural achievement helping to link the Halifax and North Bridge stations, with continued journeys on to Ovenden and Queensbury. Next to the viaduct stood the Duke William Inn, which closed in 1965 and was subsequently demolished.

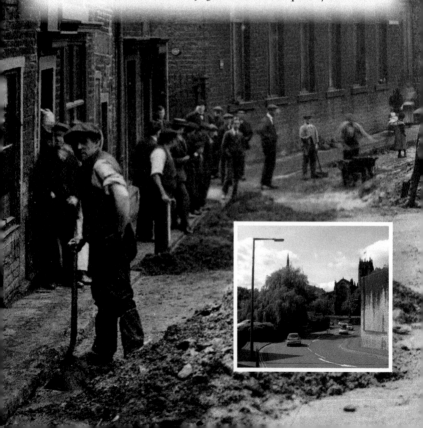

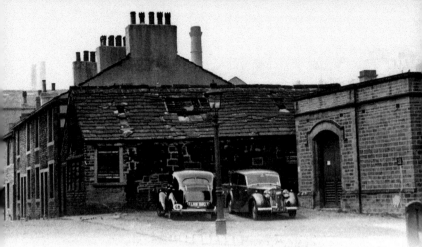

50. NELSON STREET & MOOT HALL

Nelson Street ran from King Street to Upper Kirkgate, near the parish church. At the end of Nelson Street stood the Moot Hall, where the Lord of the Manor held his court. Many criminals would have been led off to the Halifax Gibbet from here. Unfortunately, after years of neglect, what was considered Halifax's oldest building at the time was not deemed of significant importance by the Ministry of Works to preserve and the building was demolished in June 1957. Nelson Street itself is long gone, although an inscribed stone marks the Moot Hall site, which has been retained.

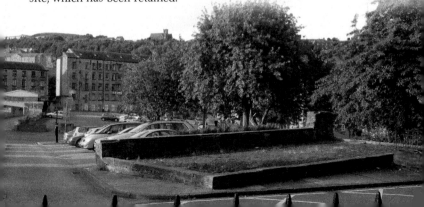

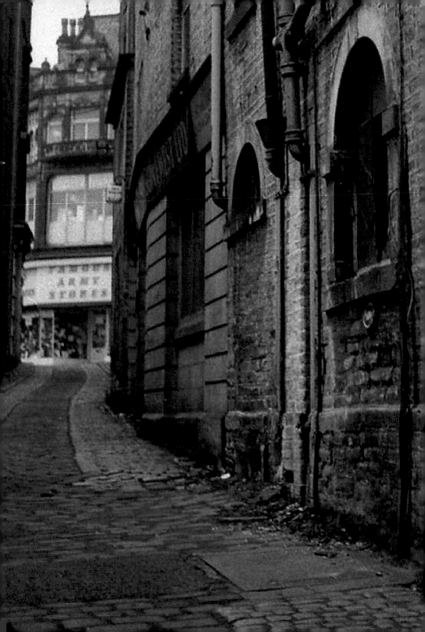

51. GAOL LANE

Although Goal Lane still exists between the Halifax Bank Woolshops Branch and the Halifax Central Library, nothing exists to show how narrow this lane was. Despite its narrowness it was here, in 1662, that the Debtor's Gaol was opened; the small semi-circular windows being the only external signs of its previous use. The gaol was rebuilt in the early 1700s but continued in use until the 1840s when the new gaol at Hanson Lane eventually took over. All these properties were demolished in the early 1970s.

ACKNOWLEDGEMENTS

Halifax is fortunate as over the years many photographers have captured images of the town that allow us to look back and compare the many changes that have occurred. I would like to give my thanks to all those photographers as, without them, this book would not have been possible.

The town has also been fortunate to have many people who have dedicated parts of their lives to researching and documenting the various elements making up the history of Halifax, either on an individual basis or as part of an organisation such as the Halifax Antiquarian Society or using more modern techniques such as Facebook or sites on the Web, to all of these I extend my thanks.

I would also like to extend my thanks to the staff at the Calderdale Central Library for their assistance during my research and to all those, past and present, who work for our local papers and who continue to capture, record and chronicle events throughout the town.

Finally, I would like to extend thanks to my partner, Joyce, who has shown her patience once again while I have researched and 'run' around the town taking photographs and for reading, encouraging and supporting me whilst putting this book together.